OFFICIAL

FORTNITE

HOW TO DRAW 3

BATTLE PASS EDITION

WILDFIRE

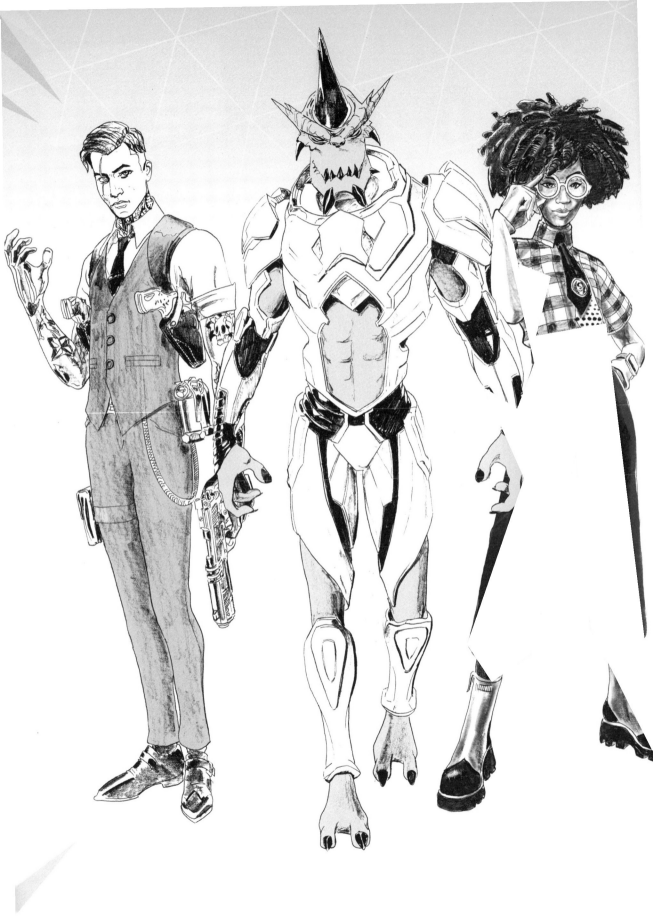

CONTENTS

DRAWING TIPS:
HANDS AND EYES

Fortnite's cast of characters stand in dynamic poses. With their bodies tilted in different directions, common features can be difficult to draw. Hands and eyes are especially tricky to proportion correctly when the character isn't looking straight ahead. Let's look at some useful tips to give you confidence to tackle these body parts in any pose!

HANDS

All hands are made up of rectangles and cylinders.

Fingers are the key component when drawing hands. While the angle and positioning of the hand may change, finger sizes always remain the same. Understanding their proportions will help you draw hands in any pose. Take time getting to know the arcs in the hand: confidently placing base knuckles, mid knuckles and fingertips will help you, no matter how the fingers are spread in a drawing.

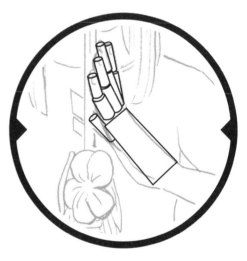

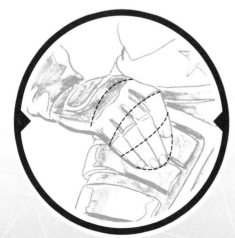

Look for straight lines and curves in a hand's outline, such as the curve of the palm and an angular bend in the wrist. This applies to fingers, too. They are often straight on the top and curved beneath.

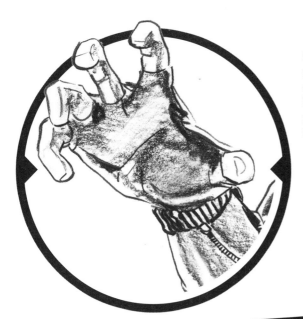

Hands rarely sit in uniform poses. Add a dash of personality to your drawing by slightly adjusting digits. Look at the way the fingers stretch and curl in this example. Capturing the fingers in different positions creates a realistic sense of movement, making your drawing even more lifelike!

TOP ART TIP!

Most artists use reference images when drawing. Try looking at your own hands to see how they move and bend to capture realistic poses.

EYES

The slightest tilt of the head can drastically change the eyes' appearance. Practice drawing faces at different angles to get familiar with the small changes a side glance or tuck of the chin can make!

Eyes are important for capturing emotion in your character's expression. But it can be tricky to make sure they are looking in the right direction.

It's important to remember the eye is a sphere. Even when covered with eyelids and lashes, the core shape remains the same.

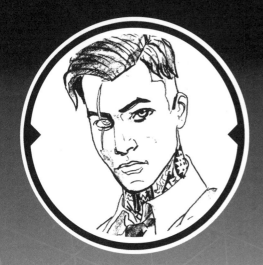

When a character is looking at us from a side angle, we see less of the iris and pupil and more of the white of the eye. The more white there is around the eye, the easier it is to recognize its position on the core sphere shape, which helps us understand where the character is looking. When the head is angled, the iris and pupil appear narrower than they do when a character looks directly at us. In fact, the whole eye appears narrower!

TOP ART TIP!

Don't forget eyebrows. They are essential for drawing interesting expressions!

HOW TO DRAW:
BANANOPE

1 Sketch Bananope's base shape. A large triangle forms the head, rectangles form the collar, and a rounded square forms the hand.

2 Draw large semi-circles for the eyes. Sketch a hexagon at the tip. Use curved lines to mark the collar and shoulder pads.

3 Curve sections of the banana skin away from the core shape. Add a frown and jagged lines to the shoulder pads. Mark finger placement.

4 Use curved lines to outline four fingers. Sketch the crown of leaves and add small detail lines to the tip, peel, and mouth.

TOP ART TIP!

The hand has a cartoony style. Keep your lines simple. Indent slightly at the base and around the thumb to create a more interesting shape.

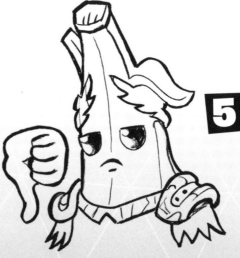

5 Use heavy pressure to firm up Bananope's outline. Shade its eyes, leaving a slight shine. Mark areas of shadow and highlights on the metallic armor.

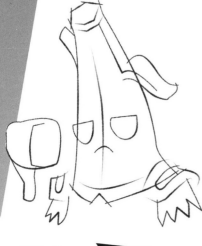

HOW TO DRAW:
EGGY

1 Begin with a simple oval. Mark a vertical guideline down the center and a horizontal line along the top third of the egg shape.

2 Use jagged lines to create the cracked shell. These lines should sit halfway between the horizontal guide and the larger outline on the top and bottom.

3 Lightly place the eyes and beak with simple ovals. Wavy lines create the helmet strap.

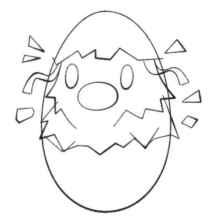

4 Triangles create fluffy feathers around the face and upper body. Add a few small random shapes for shell splinters.

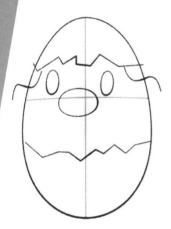
5 Erase remaining guidelines. Draw Eggy's eyes and mouth. Small curves and ovals create rosy, dimpled cheeks.

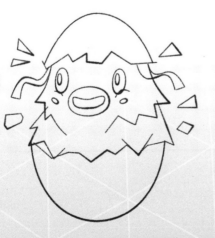
6 Thicken Eggy's outline and add dark shading to the eyes and helmet strap. Decorate the shell with simple lines.

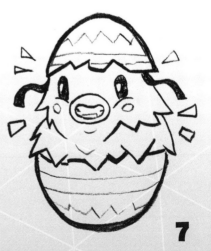

7

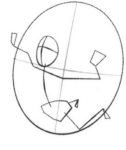

HOW TO DRAW: HOT DROP

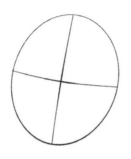

1 Begin with a large oval. Sketch guidelines through the middle of the shape.

2 Lightly pencil in a base framework. This figure needs to look good in silhouette, so exaggerate their pose.

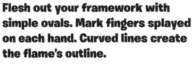

3 Flesh out your framework with simple ovals. Mark fingers splayed on each hand. Curved lines create the flame's outline.

4 Lightly sketch a simpler version of the flame's shape inside the larger outline. Leave a slight gap.

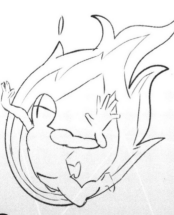

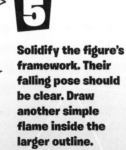

5 Solidify the figure's framework. Their falling pose should be clear. Draw another simple flame inside the larger outline.

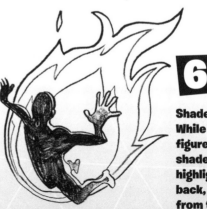

6 Shade your drawing. While most of your figure will be darkly shaded, leave highlights on their back, reflecting light from the flames.

HOW TO DRAW: MEOW

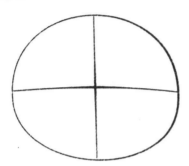

1 Sketch a large oval, marking guidelines through the center. The horizontal line lightly curves with the oval's shape.

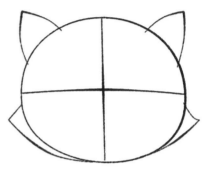

2 Add two triangular ears. Thin triangles curve to create the fluff around Meow's cheeks.

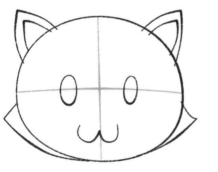

3 Sketch Meow's inner ears. Two large ovals form its eyes. Draw a W-shape for the mouth, keeping the curves soft.

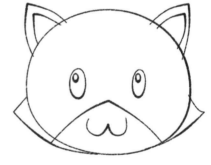

4 Sketch small circles to mark highlights in its eyes. Pencil the triangular marking around the mouth.

TOP ART TIP!
Simple lines are best when drawing Emoticons! Their small size means there isn't much room for detail, so keep things crisp and clear.

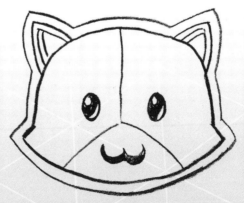

5 Firm up your drawing and carefully create a border around Meow. Add a short vertical line for the calico markings. Shade the eyes and mouth.

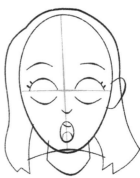

HOW TO DRAW:
OH NO!

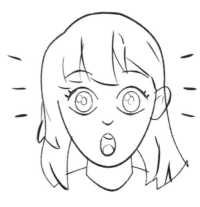

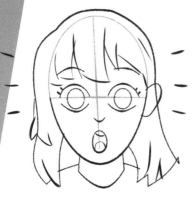

1 Sketch an oval shape, adding guidelines to the center of the face.

2 Outline the facial features. The expression is exaggerated, so make the eyes big and wide. Sketch the hairline.

3 Large circles form the eyes. Use rough lines to place the bangs. Add three short reaction lines on each side of the head.

4 Sketch the pupil and a shiny highlight in each eye using neat circles.

TOP ART TIP!
Converging lines draw attention to a character's face. They are a simple but effective way to add a touch of drama!

5 Firm up your pencil work. Use thick lines for the brows and eyelashes to draw focus to the shocked expression.

HOW TO DRAW: OHM'S REVENGE

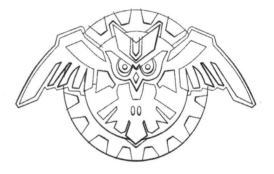

 1 Use a compass to neatly layer two circles, one slightly larger than the other. Add guides to the smaller circle.

2 Sketch the owl's symmetrical shape. Rectangles form the body and wings. Use a ruler to keep edges straight.

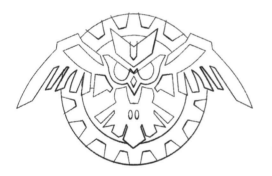

3 Outline the owl's eyes, beak, and feet. Evenly pencil trapezoids around the outer edge of the larger circle.

4 Firm up the owl's shape. Lightly frame the wings. Outline the eyes. Small circles create its firm stare.

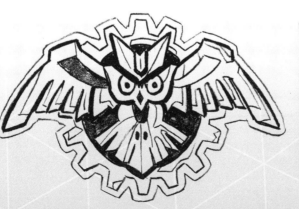

 5

Darkly shade your drawing. Apply heavy pressure when outlining the owl, erasing unwanted lines around the background cog.

HOW TO DRAW:
OLLIE
AWAY

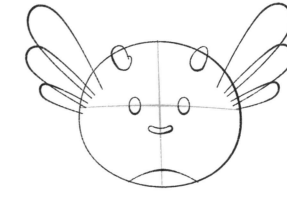

1 Begin with a sketch of a wide oval. Mark guidelines through its center.

2 Overlap large U-shapes for the wings. Ovals form the horns and mouth. Sketch the smile and add a semi-circle to outline the belly.

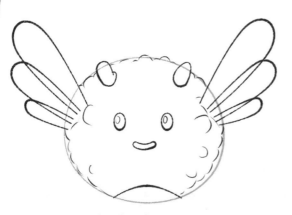

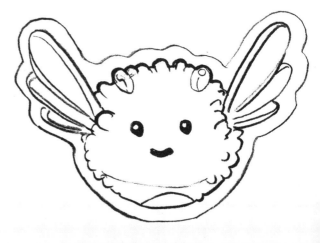

3 Add a series of small C-curves to Ollie Away's body to create a bumpy texture. Mark bright highlights in its eyes.

4 Firm up your linework and darkly shade the eyes and mouth. Mark highlights on the wings and horns. Lightly frame the overall outline.

HOW TO DRAW: SKULLY SHOUT

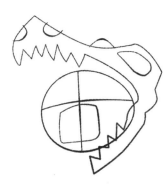

1 Begin with an oval shape. The angle of Skully Shout's face means the oval stretches sideways.

2 Frame the oval with a skull outline. Create sharp teeth with jagged lines. Long curves create the jaw.

3 Add a rounded square for the open mouth. Teardrop shapes form the skull's eye, and semi-circles create nostrils.

4 Overlap large tear shapes to create feathers. Add more jagged teeth. V-shapes create closed eyes.

5 Add short lines for eyebrows and cheek markings. Draw three small triangles with jagged bases.

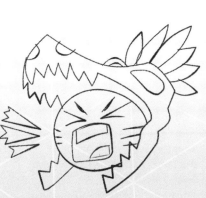

6 Darkly shade the open mouths and the skull's eye. Draw triangles on the face's cheek. Thicken the outline to finish.

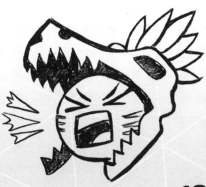

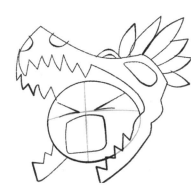

13

HOW TO DRAW:
ADVENTURE PACK

1

Get ready for adventure by sketching the pack's base shape and marking central guidelines.

2

Add shape to the upper right quadrant. This curve and triangle will form the shield. Draw a straight, diagonal line.

TOP ART TIP!

Contrast the soft curves of the fabric pack with the hard, sharp lines of the shield and sword for a dynamic look!

3

Add the pouch on the lower left quadrant. Sketch a small rectangle in the pocket and an octagon-shaped keyring.

4

Draw the sword, building symmetrically around your diagonal guideline. Add shape to the shield.

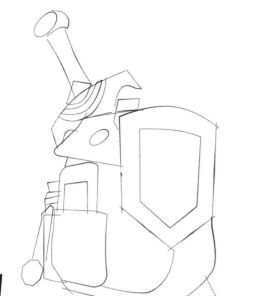

5

Outline the pack's lid, adding a circle in the center. Add depth to the sword. Diamond shapes form the blade's pointed tip.

6

Begin decorating your Back Bling. Add stitching detail to the base and lid, and draw the iconic tree on the shield.

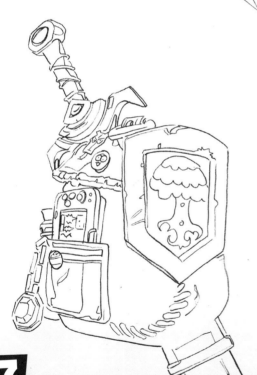

7

Firm up your line work. Add finer detail to the sword's grip and cross-guard. Pencil dents and scratches into the metal.

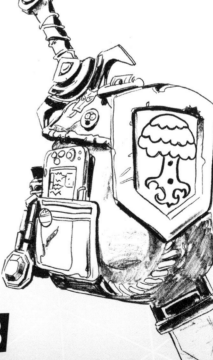

8

Use thick shading to add depth to the sword and shield. Add soft shading to the pack, varying the direction of your strokes to create the bulges of a hero's backpack.

HOW TO DRAW:
BREAKFAST BOUNTY

1 Start by sketching the sack's outline, making sure it's big enough to fit stacks of pancakes!

2 Use jagged lines to add a large rip. Curve the torn sections away from the center of the bag.

4 Use curved lines to tie rope around the neck of the sack, its ends hanging low. Sketch a stack of pancakes, visible through the rip.

3 Short lines create folds at the top of the sack, adding depth. Connect an uneven, curved line to the jagged rip.

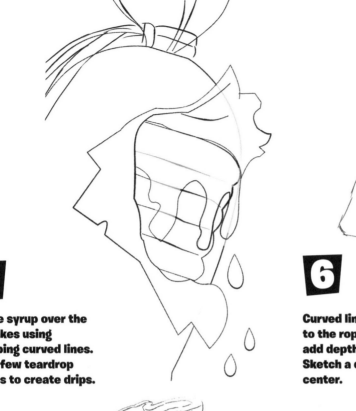

5

Drizzle syrup over the pancakes using sweeping curved lines. Add a few teardrop shapes to create drips.

6

Curved lines add texture to the rope, and wavy lines add depth to the sack. Sketch a dollar sign in the center.

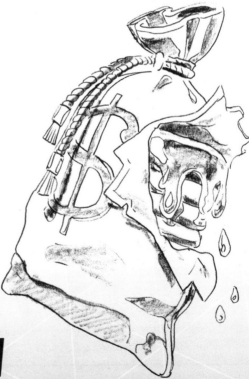

7

Tidy your drawing, adding shape to the rope. Mark highlights on the syrup to give it a gloopy shine.

8

Add a touch of shading to your drawing. Adding value to the creases of the fabric will create a 3D look.

HOW TO DRAW:
KABAG

1

Outline this fashionable Back Bling by sketching a square and triangle, softening the lines and curving the corners.

2 Sketch a four-point star, keeping the lines even. Begin outlining the grenade.

3 Three small semi-circles form the spikes. Use ovals for the zip, and straight lines for the grenade's lever.

TOP ART TIP!

To capture the curve of the bag, use darker lines where objects are closer and lighter lines for areas further from view.

4 Add shape to the star. The lines forming the cross aren't straight but slightly diagonal, creating a peak at the center point.

6 Sketch bubble letters across the bag. Use rectangles to create the grenade's serrated body.

5 Add shape to the zip, connecting the tab to the grenade's pin. Follow your base shape to add depth to the Back Bling.

7 Firm up the grenade's shape. Outline the lettering, and mark areas of light and shadow.

8 Shade your Back Bling, contrasting thick blacks with bright whites to create an explosive design!

HOW TO DRAW:
BIG HAUL

 1 Begin by sketching two rectangles, overlapping slightly. Add the handle. Repeat on the other side, flipping the design.

 2 Add depth to the top rectangles, turning them into cuboids. Perspective will mean different edges appear 3D.

3 Begin outlining the handcuffs. A large circle connects the two briefcase handles. Slim ovals form the loose cuffs.

 4 Have fun layering in piles of cash! Overlap rectangles in different directions, adding light curves to a few edges. Draw some outside the cases to create the illusion it's flying away.

20

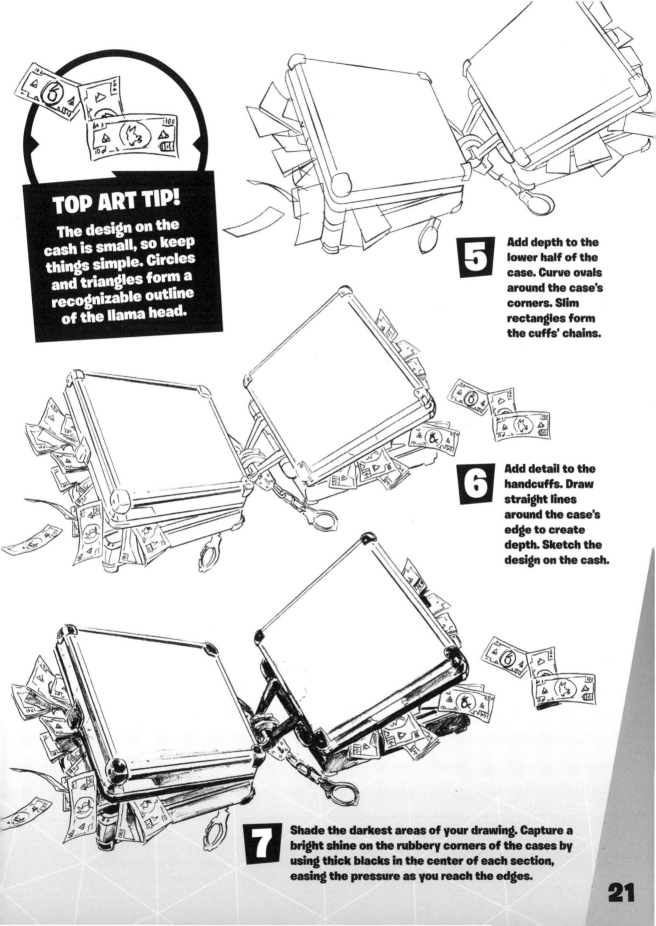

TOP ART TIP!
The design on the cash is small, so keep things simple. Circles and triangles form a recognizable outline of the llama head.

5 Add depth to the lower half of the case. Curve ovals around the case's corners. Slim rectangles form the cuffs' chains.

6 Add detail to the handcuffs. Draw straight lines around the case's edge to create depth. Sketch the design on the cash.

7 Shade the darkest areas of your drawing. Capture a bright shine on the rubbery corners of the cases by using thick blacks in the center of each section, easing the pressure as you reach the edges.

HOW TO DRAW:
BLADE RAVEN

1 To draw this Glider, start with a light sketch of the frame. A wide octagon forms the center. Pencil in wings and extend the vertical guideline past the octagon's base.

2 Add two triangles and two circles to the octagon. Outline the cape, adding a few rough lines to capture the torn effect.

3 With Blade Raven's base complete, it's time to start adding shape. Carefully follow your guides to give the wings and armor a 3D look. Add a guide for the raven's foot, bending sharply.

TOP ART TIP!

Blade Raven's armor means its wings are much more uniform than a bird's wings. Keep your lines crisp to create a hard, metallic look rather than a soft, feathery appearance.

4 Sketch the shape of the Glider's feathers. They are all slightly different sizes and curve at the tip. This gives the wings a more interesting look.

22

 5 Add another layer of feathers to the wings, including a forked blade on the left wing. Sketch cones to mark spikes on the base of his armor and add tears to his cape.

6 Use your guides to place the regal design at the base of the octagon. It can be broken down into triangles for its crown, beak, and wings, and a large diamond for its tail.

7 Add depth to the bladed wings, carefully following the core outlines. Connected cylinders form the foot. Add soft lines to the cape to show the weight of the fabric.

8 Shade the cape, moving your pencil with the bumps and folds of the fabric. Adding dark value to the shadowy areas of the wings will make them soar off the page!

HOW TO DRAW:
BOMBS AWAY!

1 Begin by sketching a long, thin oval, marking central guidelines. Draw a cylinder, slightly removed from the oval's base curve.

2 Create a firmer outline, joining the oval and cylinder together. Carefully follow your guidelines to begin shaping the tail unit.

3 Angled rectangles form Bombs Away's fins. Curve lines around the bomb's nose and base.

TOP ART TIP!
Practice drawing contour lines to see how they impact 3D shapes. Contour lines are a valuable tool for capturing the curves of rounded objects.

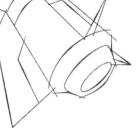

4

Continue adding detail to the fins by sketching rectangles. Add depth to the upright fin, with a slim triangle forming its base.

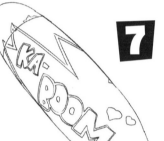

5

Small circles create the pins along the collar. Sketch simple diagonal lines on the fins. Curve lines around each end of the tail unit.

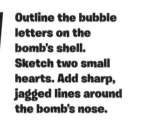

6

Outline the bubble letters on the bomb's shell. Sketch two small hearts. Add sharp, jagged lines around the bomb's nose.

7

Start firming up your drawing, erasing rough lines. Outline the lettering and explosive detail around the nose. Use clean, mechanical lines to tidy the detail on the tail unit.

8

Finish by adding a touch of shading to your drawing. Move your pencil with the contour of the shell to capture the curved shape.

TOP ART TIP!

Gradually lessen the pressure on your pencil as you move across the page for a smooth transition between dark and light sections. This method is called "gradating."

HOW TO DRAW: METALMARK

1 Begin by pencilling a light polygon. Extend six straight lines from the central shape.

2 Outline the shape of the wings. Begin with parallelograms for the upper wings, indenting where the metal folds in.

TOP ART TIP!

Carefully consider the angle and position of the wings. The right wing appears much shorter and as if it is raised higher.

3 Begin layering on the raised sections of the upper wings. Follow your base shape closely. Mark two rough circles for the wing hinges.

4 Pencil in the shape of the thrusters. Long, thin kite shapes form the pointed tips. Use curved lines to mark the raised section in the Glider's main body.

5 Let's begin adding 3D shape! Pencil panels on the wings and body. Sketch small squares to mark the thrusters.

6 Start adding detail to your drawing. Stack circles to create the wing hinges. Short, soft lines mark the bumps and grooves on the metal.

7 Layer sharp, zigzag lines to create the 3D effect on the upper wings. Sketch the logo on the body. Contour lines around the thrusters to make their circular shape stand out.

8 Finish by adding value to your drawing. Use heavy blacks to show that the small upper wings are lifted. You're ready to flutter into action!

27

HOW TO DRAW: OHM

1 Lightly sketch the Glider's framework. Ovals create the body. Curve the wings away from the center and mark lines for the feathers, varying their size.

2 Outline the feathers using long, curved parallelograms for the wings and kite shapes for the tail. Add two ovals at the shoulders and softly sketch the talons.

3 Pencil in a smaller layer of wings, carefully following the shape of the base section. Sketch Ohm's diamond ears and large circular eyes.

TOP ART TIP!

Unlike human eyes, the top of Ohm's eyes sit on the central guideline. Notice the right eye overlaps with its cheek as Ohm is at a slight angle.

4 Add a triangular beak. Begin forming the armor on the wings. For the smaller sections, sketch squares then bend them out of shape. Add its perch.

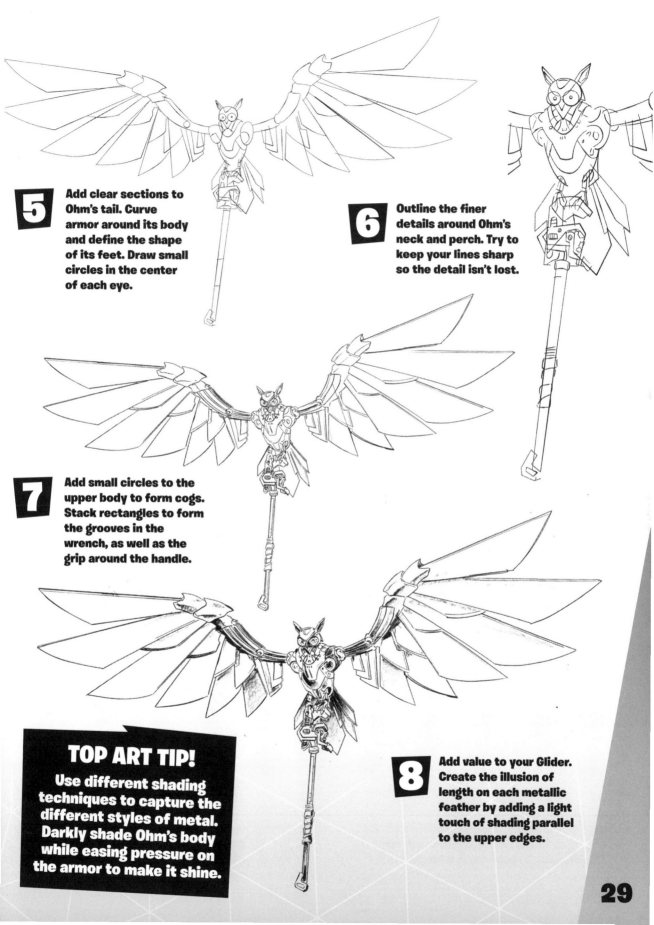

5 Add clear sections to Ohm's tail. Curve armor around its body and define the shape of its feet. Draw small circles in the center of each eye.

6 Outline the finer details around Ohm's neck and perch. Try to keep your lines sharp so the detail isn't lost.

7 Add small circles to the upper body to form cogs. Stack rectangles to form the grooves in the wrench, as well as the grip around the handle.

TOP ART TIP!
Use different shading techniques to capture the different styles of metal. Darkly shade Ohm's body while easing pressure on the armor to make it shine.

8 Add value to your Glider. Create the illusion of length on each metallic feather by adding a light touch of shading parallel to the upper edges.

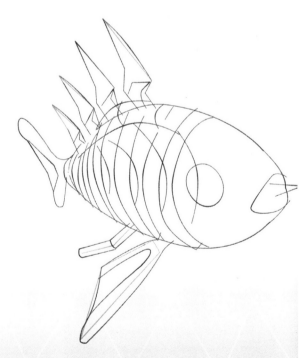

HOW TO DRAW:
SKELLEFISH

1 A long oval forms this Glider's base shape. Add central guidelines, curving with the shape of its body.

2 Triangles form Skellefish's fins, while lightning-bolt shapes create the spikes on the Glider's back.

3 Curve lines around Skellefish's body. Add a large circle for the eye and a wide U-shape for the mouth.

4 Curve lines along the body in the opposite direction. Add shape to the fins, using wide U-shapes to create indents. Two cylinders form the visible Glider handle.

5 Thicken the ribs by drawing curved lines parallel to each existing line. Draw a smaller circle inside the eye, and a smaller oval within the mouth.

TOP ART TIP!
Keep your lines light until your sketch is complete. Soft pencil marks are much easier to tweak and erase than hard, heavy lines.

6 Erase rough pencil work and firm up Skellefish's shape. Take your time adding depth to the curved ribs. Add light lines to the center of the fins.

7 Shade Skellefish's open mouth and the darkest areas of its ribs. Add soft touches of shadow to its face, spikes and fins, following the curves of its body and features with your pencil.

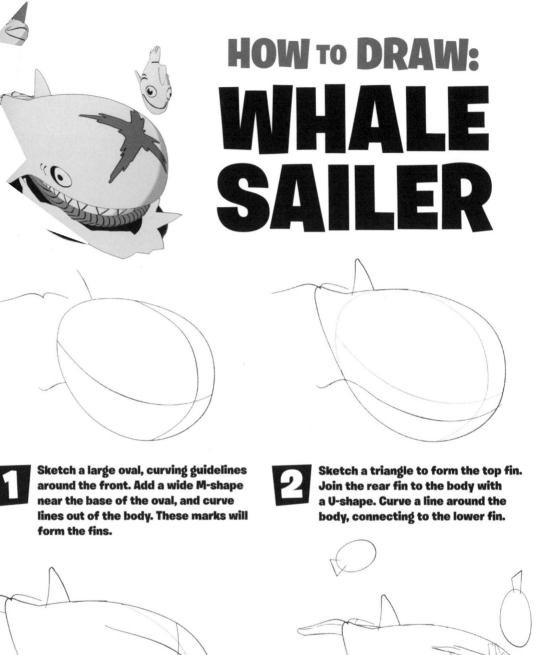

HOW TO DRAW:
WHALE SAILER

1 Sketch a large oval, curving guidelines around the front. Add a wide M-shape near the base of the oval, and curve lines out of the body. These marks will form the fins.

2 Sketch a triangle to form the top fin. Join the rear fin to the body with a U-shape. Curve a line around the body, connecting to the lower fin.

3 Add shape to the lower fin. Sketch a large oval for the eye. A curved line forms its grin. Draw an X-shape across its head, bending the lines with the curve of its body.

4 Sketch sharp triangles to form its teeth and small semi-circles around its lower lip. Add a small pupil to its eye and draw rough lines around the X. Begin sketching fish using ovals and triangles.

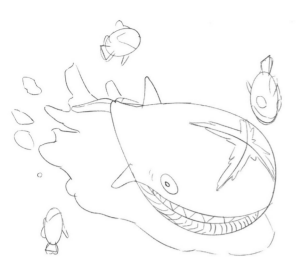

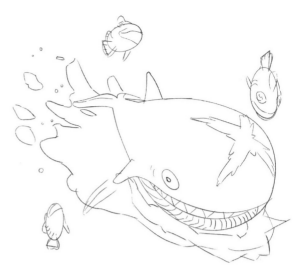

5 Have fun surrounding Whale Sailer with a large, messy splash of inky water. Draw mouths and eyes on the fish.

6 Draw pupils and gills on the fish. Extend Whale Sailer's lower fin with three curved lines so it cuts through the water.

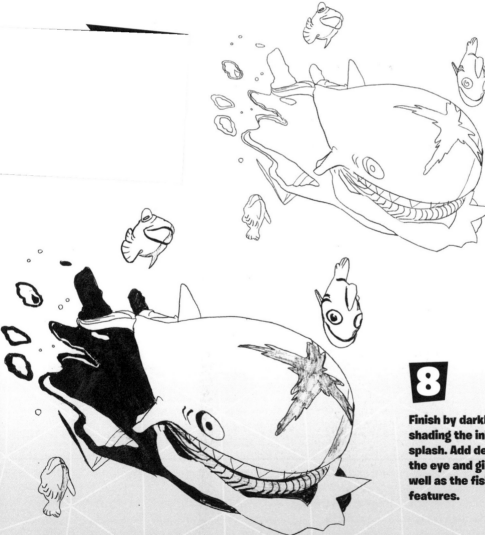

7 Continue adding shape to the water splash, marking sections of ink. Firm up your pencil work and erase rough lines.

8 Finish by darkly shading the ink splash. Add depth to the eye and gills, as well as the fish's features.

HOW TO DRAW:
ZYG RAY

1 Begin with a light sketch of your Glider's framework. Add four curved lines for Zyg Ray's tail.

2 Add a wide, slim octagon to the center of the Glider's body. Use your guidelines to begin adding shape to the central tail.

4 Mark four circles on the Glider's body, considering the tilted angle of the drawing. Add shape to the stinger.

3 Sketch a slim trapezoid and two semi-circles at the top of the Glider. Thicken the curved claspers and add a rectangle to the base of the tail.

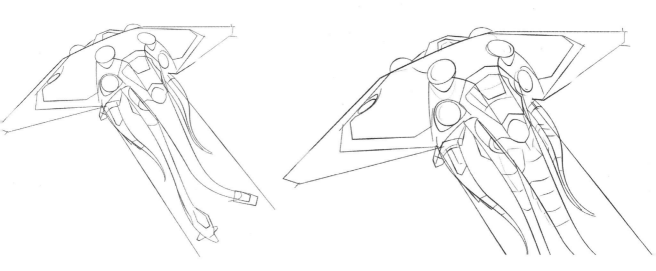

5 Continue adding shape to the main body, closely following the outline of the inner section.

6 Curve lines around the tail, stinger and claspers to create stacked, robotic sections.

TOP ART TIP!
Contrast the straight lines of the mechanical body with the smooth, freeflowing curves of the tail section to create a sense of movement.

7 Firm up your pencil work. Add light curved lines to capture the contours in the Glider's body. Frame the tail section with thin parallel lines.

8 Add a touch of value to your drawing, gradating in the darkest areas. Place light shadows to highlight the curves in the metal.

HOW TO DRAW: BOULDER BREAKER

1 Create this dual weapon's base shape by sketching two large triangles. Cross two long lines, adding slight bends in each.

2 Use your guidelines to outline the axe heads. Draw rectangles at the top, mid-point and base of each line.

3 Triangles and trapezoids form the sharp spike connected to the butt of each axe. Begin forming the handles, joining the rectangles together.

4 Add curved lines to the axe blades. Begin adding depth to the base shapes. Mark rectangular indents on the top of each head and outline the fabric loop handles.

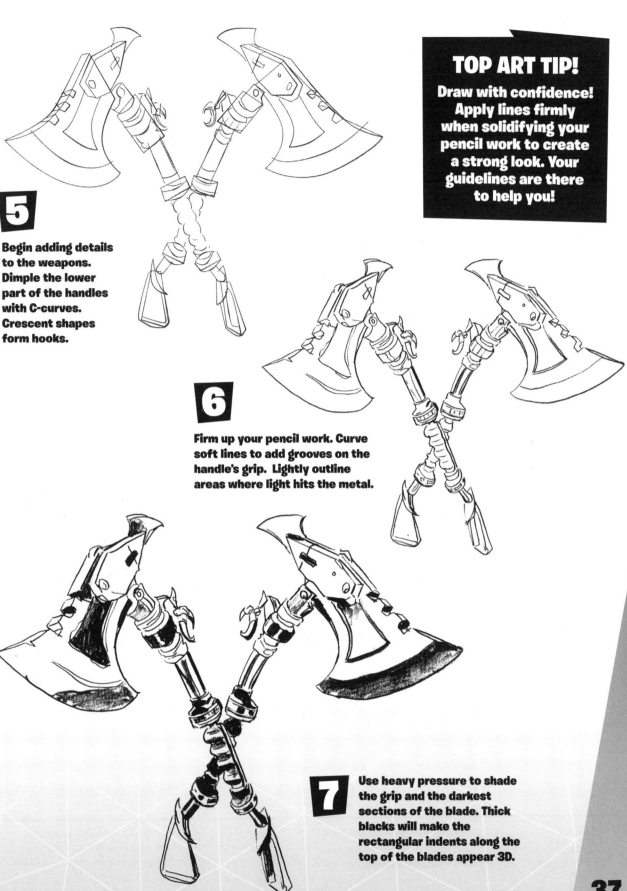

5

Begin adding details
to the weapons.
Dimple the lower
part of the handles
with C-curves.
Crescent shapes
form hooks.

6

Firm up your pencil work. Curve
soft lines to add grooves on the
handle's grip. Lightly outline
areas where light hits the metal.

7

Use heavy pressure to shade
the grip and the darkest
sections of the blade. Thick
blacks will make the
rectangular indents along the
top of the blades appear 3D.

HOW TO DRAW:
CHAINSAUR

1 Begin outlining this dinosaw by sketching a long rectangle and lightly curved line. The head can be broken into a rectangle and trapezoid.

2 Sketch the curve of the chainsaw blade and outline the bottom jaw. Mark the handle and grip.

3 Continue adding shape to the weapon. A cuboid joins the handle to the skull. Sketch a light square in the center of the handle.

4 Draw a series of circles to mark the holes in the skull and the bolt on the blade. Add a cone to form a sharp spike for the chainsaw's pull start.

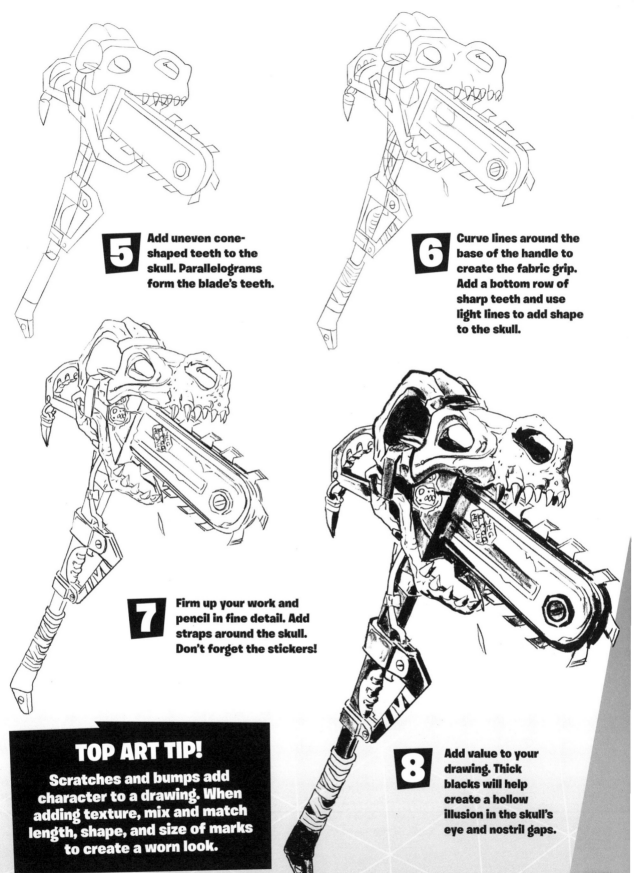

5 Add uneven cone-shaped teeth to the skull. Parallelograms form the blade's teeth.

6 Curve lines around the base of the handle to create the fabric grip. Add a bottom row of sharp teeth and use light lines to add shape to the skull.

7 Firm up your work and pencil in fine detail. Add straps around the skull. Don't forget the stickers!

TOP ART TIP!

Scratches and bumps add character to a drawing. When adding texture, mix and match length, shape, and size of marks to create a worn look.

8 Add value to your drawing. Thick blacks will help create a hollow illusion in the skull's eye and nostril gaps.

HOW TO DRAW:
BEASTFANG

1 Mark long guidelines. Sketch a trapezoid at the center mark and two semi-circles for the blades. Add a circle to the handle's base.

2 Sketch a triangle point at the top of the axe. Curve the blades and sketch the handle.

3 Turn the pointed tip into a 3D cone, resting on a slim cylinder. Outline the inner sections of the blades.

4 Draw spikes around the blade edges. The spikes on the blade further from view look slightly skewed. Add a small circle and three triangles to the base.

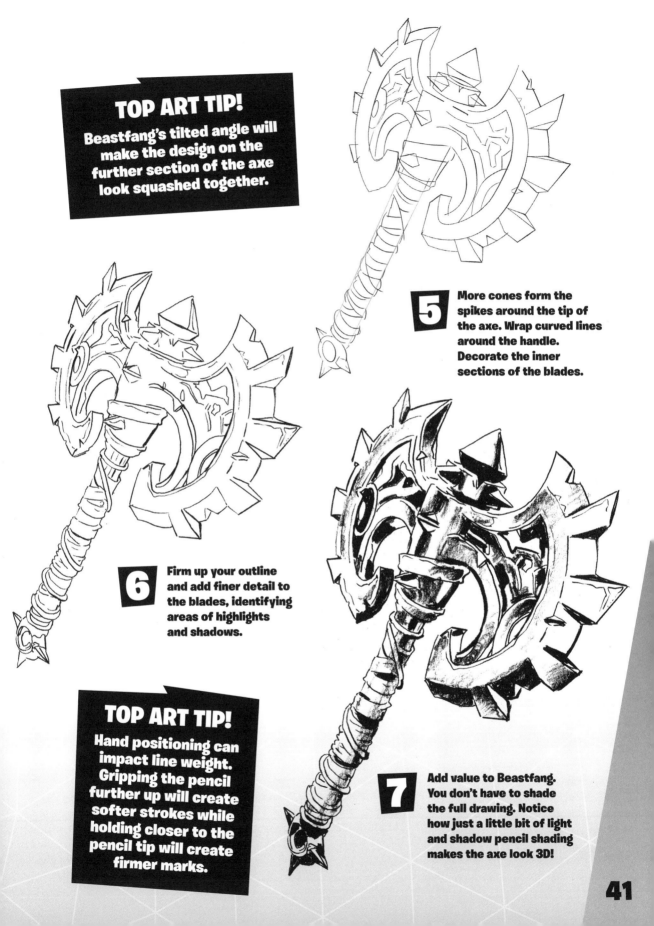

TOP ART TIP!

Beastfang's tilted angle will make the design on the further section of the axe look squashed together.

5 More cones form the spikes around the tip of the axe. Wrap curved lines around the handle. Decorate the inner sections of the blades.

6 Firm up your outline and add finer detail to the blades, identifying areas of highlights and shadows.

TOP ART TIP!

Hand positioning can impact line weight. Gripping the pencil further up will create softer strokes while holding closer to the pencil tip will create firmer marks.

7 Add value to Beastfang. You don't have to shade the full drawing. Notice how just a little bit of light and shadow pencil shading makes the axe look 3D!

HOW TO DRAW:
DRUMMIES

1
These delicious Drummies are made of two large circles, long lines and triangles. Don't forget guidelines in the center of each circle!

2
Connect the circles and triangles with long, curved lines. Notice they straighten as they become slim towards the bottom.

TOP ART TIP!
Notice the central guidelines are at slightly different angles. Changing the direction of your contour lines will change the way a subject is facing.

3
Use rough, wobbly lines to outline the drumsticks. Pencil in a large bite mark on one.

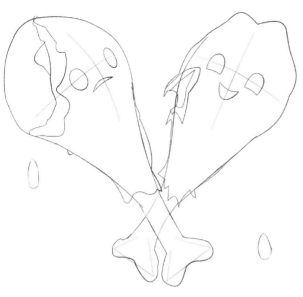

4 Sketch faces on each drumstick: one happy, the other sad. Add shape to the bones, curving around the triangle guides. Draw teardrop-shaped drips.

5 Erase any remaining rough lines and firm up the outline. Add small, light curves to the drumsticks, creating bumps in the skin and adding shape to the bone.

TOP ART TIP!

Contrast doesn't only apply to shading. The drumsticks' different expressions highlight their unique characteristics!

6 Mark shadowy areas, as well as bright highlights in the eyes and droplets. A small cylinder of bone should be peeking out of the sad drumstick's bite mark.

7 Finish by lightly shading your drawing. Curve shadows across the chicken skin to add depth. Softly shade the bone, highlighting the bumps and grooves.

HOW TO DRAW: STRINGLES

1 Start forming this acoustic Harvesting Tool by sketching two large circles, a long, straight line, and a trapezoid.

2 Using your base guides, add shape to the guitar's body and neck. Draw a small circle and carve a U-shape into the top half of the body.

3 Sketch large oval eyes and a wide, slim smile. Add depth to the body. Small cylinders create the tuning pegs.

4 Sketch small wedges in each pupil and add a semi-circle tongue. Outline the body and draw a larger circle around the sound hole.

5

Carefully sketch 8 lines from the large smile to the tuners. This can get a bit fiddly, so use a ruler to help guide you.

6

Firm up Stringles' outline, erasing any rough work. Use thick lines to outline the outer edge of the neck. Thin cylinders create the string posts.

TOP ART TIP!

High contrast shading will help capture Stringles' 2D form. Heavy blacks add shape to the guitar's body and depth to the fretboard without ruining his 2D style.

7

Shade Stringles, moving your pencil with the curves of his body. Darkly shade the neck of the guitar, leaving the strings bright white.

45

HOW TO DRAW: WRENCHERS

1 These twin battle wrenches are almost identical. Begin with long crossing lines topped with rectangular U-shapes.

2 Draw long, slim ovals for the handles with a small circle at the base of each. Rectangles form the head's base shape. Add a large circle and a rounded triangle to each head.

3 Use your guides to begin adding 3D shape to each element. Draw cubes at the base of each handle.

4 Sketch slim ovals to create the screw. Trapezoids add shape to the wrenches' cogs.

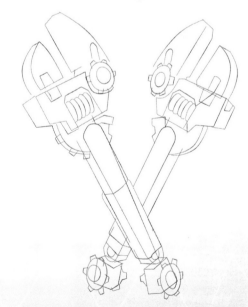

5

Follow the curve of each handle to wrap fabric around the grip. Use simple lines to detail the screws and bolts on the tools.

6

Detail your drawing. Mark areas of highlight, taking care to curve with the shape of the wrenches to emphasize the 3D appearance.

7

Darkly shade the wrenches, giving the clamps a white shine. Use light pressure with the side of your pencil when shading the grip to capture the fabric's texture.

HOW TO DRAW: AGENT JONES

1

Sketch your framework. Agent Jones is stepping forward, so his left calf line will appear slightly smaller than his right.

2

Use ovals and circles to begin adding shape to your drawing. Lightly outline his feet.

3

Use your guidelines to place his facial features, noting the slight tilt of his head. Shape his fingers, curling his right fingers over his left fist.

4

Sketch Agent Jones's clothes. He wears a fitted suit, so keep your lines close to his figure, flaring slightly around his wrists, hips, and lower legs. Draw his hairline using short, rough lines.

5

Start to pencil in details on his clothing, adding buttons, pockets, his belt buckle, and shoe laces. Draw his eyebrows and define his square jawline.

6

Draw fine lines around his eyes, nose, and chin. He's no stranger to entering The Loop, so his expression should be confident! Add texture to his hair, marking small sections with curved V-shapes.

7 Erase any rough guidelines. Use long, sharp lines to mark creases in Agent Jones's jacket and pants.

8

Draw finer details, including buttons and cufflinks. Short lines create wrinkles in the fabric around his ankles. Lightly mark areas of shadow on his face, hands, and shoes.

TOP ART TIP!

Identifying correct knuckle position makes drawing hands easier. Notice how the knuckles aren't perfectly stacked, but instead curve downwards.

50

9

Darkly shade Agent Jones's suit. As his shoes are neatly polished, gradually layer thick blacks, creating bright areas of highlight with an eraser to create a shiny look. Add soft shadows to his face, hands, and shirt. He's now ready for his latest mission!

HOW TO DRAW:
MEOWSCLES

1 Begin by lightly sketching Meowscles' framework. While his body is similar to a human figure's, his head should be round.

TOP ART TIP!

The L-shape of Meowscles' arms is essential for capturing his bulging biceps. Muscles move with the bone, so this pose tenses his bicep muscles, making them large and rounded.

2 Begin fleshing out his figure. Notice how the ovals forming his arms overlap, capturing his huge muscles.

Continue adding shape to his body, pencilling in his fists and feet. Use triangles to define his ears and cheeks, and a small curved W-shape for his mouth.

Cuboids form Meowscles' holster. Lightly sketch his gun's grip. Follow the shape of his feet to draw his boots.

Use light, jagged lines to draw the calico markings on his arms and face. Sketch light curved lines to define his swole physique. Sketch a paw print on his holster and add detail to his belt and gun grip.

6 Add detail to his sneakers. The core shape of a shoe follows the same shape as the sole of a foot. Take your time getting the base shape right, then add the thick soles, panel outlines, and laces.

TOP ART TIP!
Simple detail is often enough to make a design stand out. Use short, even dashes to create a stitch effect in the leather of the holster and belt.

7 Continue adding fine detail to your drawing, including pockets, shoelaces, and the claw marks on his pants. Lightly mark areas of shadow for shading.

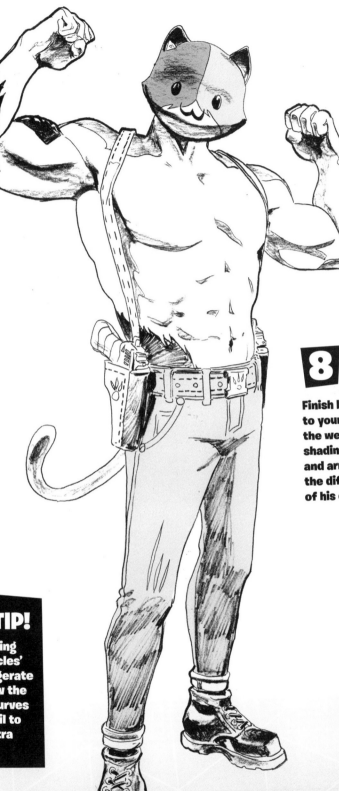

8

Finish by adding value to your drawing. Vary the weight of your shading on his face and arms to capture the different colors of his calico fur.

TOP ART TIP!

Add light shading around Meowscles' muscles to exaggerate their size. Follow the shape of their curves with your pencil to give them extra definition.

HOW TO DRAW:
DOCTOR SLONE

1 To begin drawing the Imagined Order higher-up, carefully sketch your character's framework.

2

Flesh out your framework. Notice how the angle of her pose impacts the size and length of your base ovals.

TOP ART TIP!

Take care with foreshortening in this drawing. Doctor Slone's strong stance means her leg lines will be really long compared to her arms in your base sketch.

3

Lightly mark her facial features. Draw a wide oval for her hairline. This shouldn't be a neat, perfect shape. An uneven line will create a more natural look.

4

Pencil in the shape of her clothes. Loose-fitting clothing is impacted by the body's position, with the material flowing down the body, gathering slightly around her knees and waist.

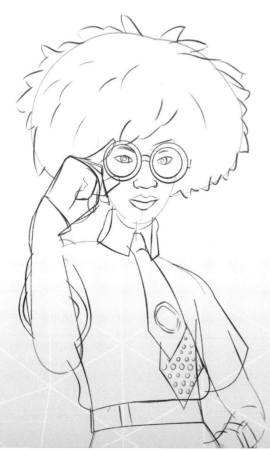

5

Begin adding texture to her hair, using soft curved lines to define sections. Carefully follow your guidelines to sketch her eyes, nose, and mouth, noting the slight forward tilt of her head.

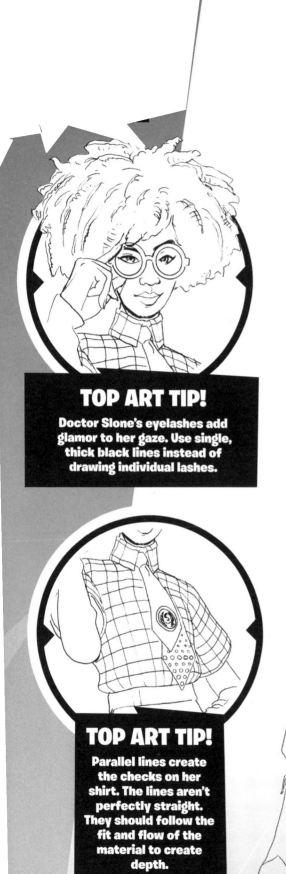

6

You should now have a clear outline of Doctor Slone. Add shape to the soles of her boots, outline her watch, and decorate her tie with a series of small circles.

TOP ART TIP!

Doctor Slone's eyelashes add glamor to her gaze. Use single, thick black lines instead of drawing individual lashes.

TOP ART TIP!

Parallel lines create the checks on her shirt. The lines aren't perfectly straight. They should follow the fit and flow of the material to create depth.

7

It's time to add finishing details. Sketch wrinkles around the wrists of her tight-fitting T-shirt and mark the logo on her tie. Use rough lines to define sections in her hair, falling away from the crown of her head.

8

Add value to your drawing. Give her upper body a strong outline. Neatly shade the shirt, varying the pressure on the checks to help the pattern pop!

TOP ART TIP!

Scumbling can capture Doctor Slone's coily hair: move your pencil in a circular motion, tightly overlapping your lines in the darkest areas and leaving space between loops where the light falls.

HOW TO DRAW:
BRUTUS

1 Sketch your character's framework. Notice the broad curve of Brutus's relaxed, confident shoulders.

TOP ART TIP!
When drawing muscular characters, exaggerate the width of their chest and give them narrower hips. Tapering in around the waist creates a large, heroic figure.

2 Begin adding shape to your frame. Brutus is bulky, so stretch your ovals far from the guidelines to capture his build.

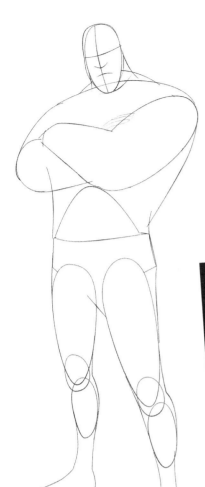

3

Continue fleshing out your character. Pencil a U-shape curve for his nose and a slightly turned-down mouth.

TOP ART TIP!

Ears are simple to draw but effective for showing the position of the head. Begin with a basic C-shape, then stretch or compress until you have the perfect form!

4

Begin sketching his neat suit. Make sure to accentuate the curve of his chest with his jacket's outline. Add semi-circles for his sunglasses.

5

Use simple shapes to add his tie, lapel, and cufflinks. Follow your guidelines to add shape to his shoes and outline his trousers, curving the fabric in around his knees.

6 Begin adding finer detail to your drawing. Sketch creases in the fabric, highlighting the stiff folds in the suit. Mark laces on his shoes and clearly outline his sunglasses.

7

Firm up your linework and erase any remaining guidelines. Notice how the material bulges around Brutus's muscles. Keep your detail lines light to add depth to the fabric. Sketch buttons on his jacket.

TOP ART TIP!

Wide-framed glasses typically stretch from the brow line to the top of the nostril. Remember: glasses sit out from the face!

8

Finish by shading your drawing. Begin with a smooth base layer of grey, then gradually build dark shadows on the suit, following the shape of the outfit to highlight his muscular figure. Contrast black and white on his sunglass lenses to give them a cool shine!

HOW TO DRAW:
FABIO SPARKLEMANE

1

Begin with a sketch of Fabio Sparklemane's framework. His head is small and round, and there is a light curve in his left calf.

3

Draw a thin triangle on his forehead and add definition to his brow. Outline his right ear and curve a smile around his muzzle.

2

Lightly add shape to your drawing. Sketch a small circle for his muzzle and extended lines for his neck.

4 Continue adding shape to Fabio's body, outlining his jacket and shorts. Take care around his wrists and ankles. When drawing the fetlocks (his ankle joints), it can be helpful to sketch circles at each joint's placement.

TOP ART TIP!

Defining the shape of hooves can be tricky. Notice how their shape changes slightly depending on their angle. Begin with simple cylinder shapes and adjust to match his stance.

5 Use your guidelines to pencil in his eyes. Although his mane and tail are blowing majestically in the breeze, the hair still moves in neat sections with only a few waves to capture a sense of movement.

HOW TO DRAW:
FABIO SPARKLEMANE

Use strong curved lines to outline his raised brow. His eyes are more circular than a human's. The angle of his head will make his left eye look small and narrow. Softly mark sections on his horn.

TOP ART TIP!

Horse hair falls in sections, just like human hair! To give it a sleek look, use long, smooth lines which curve at the end of each section.

Continue adding detail to your drawing, adding creases in Fabio's clothing. Mark areas of highlight and shadow, considering where the light will hit his hooves.

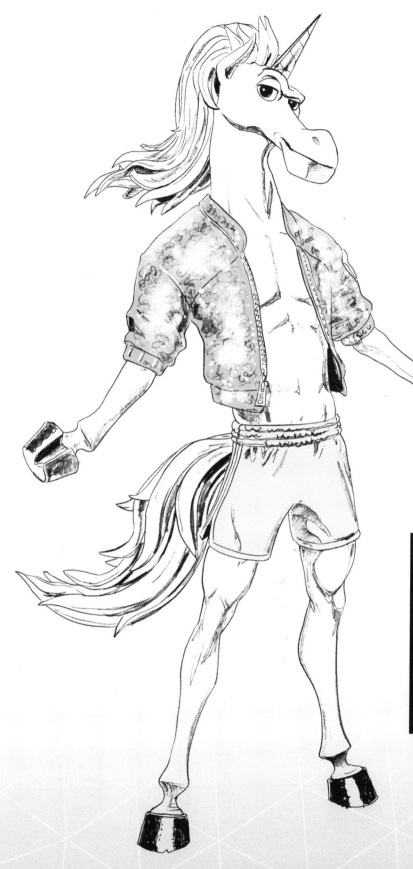

8

Finish by adding some light shading to your drawing, using shadows to add definition. High-contrast shading on his hooves will create a polished look. Fabio is ready to parade!

TOP ART TIP!

To give Fabio's jacket some extra sparkle, begin with an even layer of gray shading, then scumble swirls over the top. Finish by using your eraser to bring out glitter and highlights.

HOW TO DRAW:
TNTINA

1

Sketch TNTina's framework. Her stance is strong, matching her explosive aura!

TOP ART TIP!

Always start with a sketch of your figure's framework. Detail can be added later. Focus on getting your character's form right and the rest will fall into place.

2

Begin fleshing out her figure. Keep the ovals narrow to reflect her slim build.

3

Lightly mark TNTina's eyes and mouth, and outline her fingers and feet. Take care when adding the soft indents around her ankles.

Sketch her hairline, using rough marks. Draw her T-shirt and boots, staying close to her body's outline. Use jagged lines to add texture to her ripped shirt. Mark her grenade strap, breaking it down into simple lines and shapes.

TOP ART TIP!

Don't be afraid to layer sections of your drawing! Sketching full cylinders then erasing lines which will be covered by her fingers or dynamite in the final drawing keeps everything in proportion.

5 Curve TNTina's armor around her legs, following the shape of her thighs and calf. Use short lines to add sections to her hair. Don't forget her dynamite sticks!

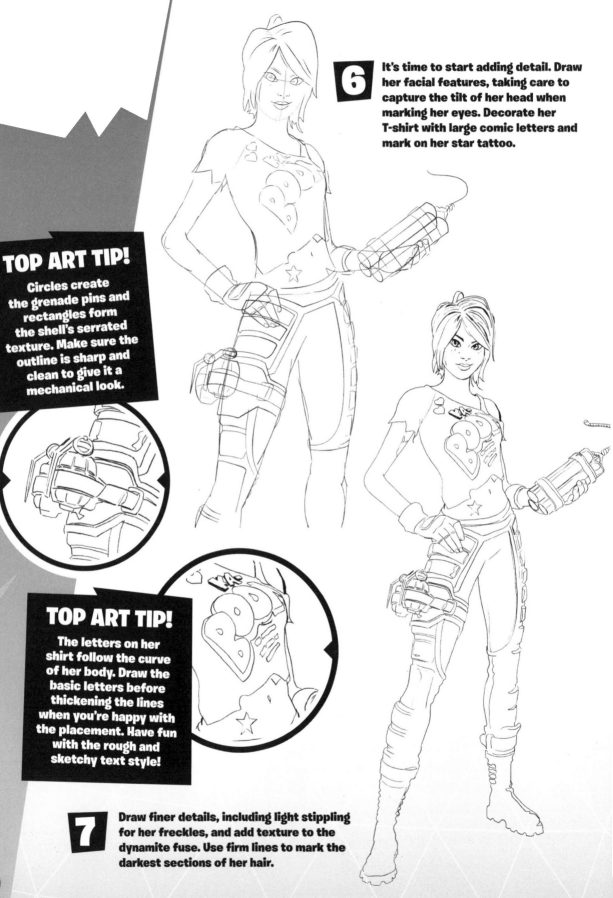

6 It's time to start adding detail. Draw her facial features, taking care to capture the tilt of her head when marking her eyes. Decorate her T-shirt with large comic letters and mark on her star tattoo.

TOP ART TIP!

Circles create the grenade pins and rectangles form the shell's serrated texture. Make sure the outline is sharp and clean to give it a mechanical look.

TOP ART TIP!

The letters on her shirt follow the curve of her body. Draw the basic letters before thickening the lines when you're happy with the placement. Have fun with the rough and sketchy text style!

7 Draw finer details, including light stippling for her freckles, and add texture to the dynamite fuse. Use firm lines to mark the darkest sections of her hair.

Finish with a BANG! by adding value to your drawing. Contrast the vibrant color of her top with the thick blacks of her pants by using bright whites and heavy shading. Add a touch of shading to the dynamite, carefully placing shadows down the length of the sticks to create a 3D effect.

TOP ART TIP!

Shading is essential for creating depth. Follow the curves of your letters when shading the KA-BOOM on her shirt so the design explodes off the page!

HOW TO DRAW:
KYMERA

1 Lightly sketch your framework. Although Kymera is an alien, his figure closely resembles a human form.

2 Start adding shape to your figure. He is standing at a slight angle, so his limbs won't be perfectly symmetrical.

3 Square off his jaw and pencil in curved lines for his fingers. Kymera's armor will make parts of his figure look bulky.

4 Begin outlining sections of Kymera's armor. Place his facial features. Draw his feet, simply rounding off your triangular guides and using slim U-shapes for toes.

5

Continue adding shape to his armor. Notice how the sections closely follow the shape of his body. The exposed areas should appear slimmer than the protected areas.

TOP ART TIP!

Use sharp lines to create Kymera's face. A large cone forms his horn and rough diamonds form the points on his chin. Long, jagged lines frame his eyes.

6 Build upon Kymera's armor, drawing close parallel lines around each section to create a sense of depth. There's lots of detail here, so take your time.

TOP ART TIP!

Kymera may only have three fingers, but his hand is just like a human's! Begin by considering knuckle placement, with his fingers forming a large C-shaped curve.

7

Sketch curved lines along his brow and short, rough lines on his horn and fearsome chin spikes to create bony texture. Clean up any rough work. His armor should have crisp lines to give it a solid look.

8

Shade your drawing. Use smooth gray to identify his skin tone, adding light shadows to the darkest areas. Careful touches of highlight on his horn will help create a threatening 3D look. You're ready to take over the galaxy!

HOW TO DRAW: CHARLOTTE

1

Lightly sketch Charlotte's framework, capturing her magical floating stance.

2

Begin adding shape to your framework. Her stance means her raised leg will appear shorter than her extended leg.

3

Mark her eyes and nose. Her head is tilted forward, making her forehead appear long. Pencil in her fingers and feet.

Outline Charlotte's clothes and sneakers. Use a ruler to lightly draw a long line, cutting through the center of her face and torso.

Pencil in her hair, using neat lines to capture the blunt style. Sketch folds on her skirt. Add shape to her sword, coming to a sharp point at the tip. Roughly outline the flower motif above the cross-guard.

TOP ART TIP!

Charlotte's skirt has a flowing appearance with lots of folds, but notice the material on top of her raised leg has smoothed out. Material always reacts to body positioning.

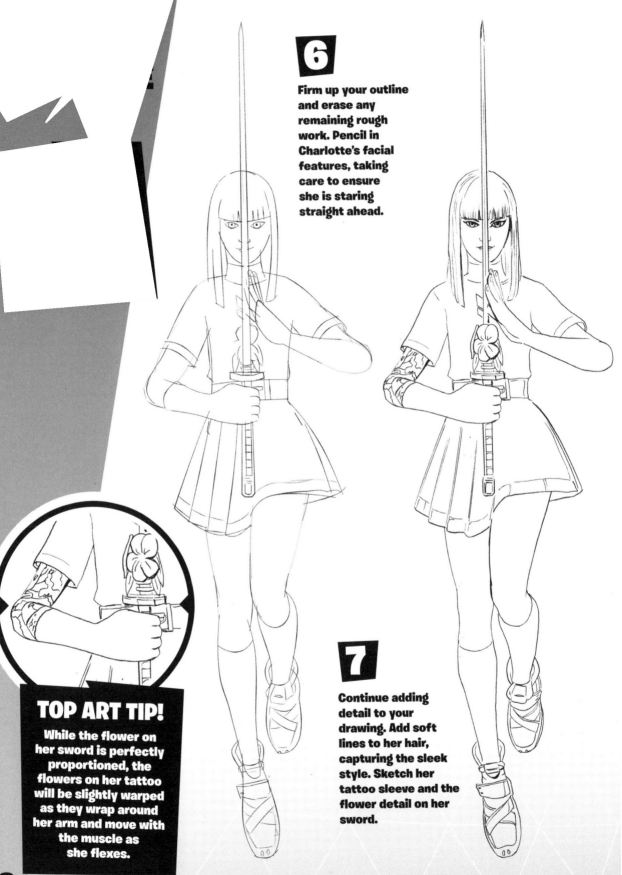

6

Firm up your outline and erase any remaining rough work. Pencil in Charlotte's facial features, taking care to ensure she is staring straight ahead.

7

Continue adding detail to your drawing. Add soft lines to her hair, capturing the sleek style. Sketch her tattoo sleeve and the flower detail on her sword.

TOP ART TIP!

While the flower on her sword is perfectly proportioned, the flowers on her tattoo will be slightly warped as they wrap around her arm and move with the muscle as she flexes.

TOP ART TIP!

You don't have to use solid shading to create sleek black hair. Instead, contrast dark shadows with bright highlights. Don't forget to follow the shape of the hair, creating defined sections.

8

Finish by adding value. Although Charlotte's outfit is dark, using heavy blacks sparingly is a more effective way of adding depth to your drawing than darkly shading all her clothes. Add soft shadows. Charlotte's ready to slay!

HOW TO DRAW: TOONA FISH

1

Begin drawing this grayscale guppy by sketching a loose framework. Notice his long straight legs and soft curves at his elbows.

2

Keeping your lines soft, pencil in his outline, adding knobbly knees, large circular eyes, and a bean-shaped mouth.

TOP ART TIP!

The more cartoony the style, the stricter the drawing rules. Adding realistic elements to a cartoony drawing is jarring, so make sure to keep your 2D style consistent!

3 Continue adding shape to Toona Fish, keeping your lines light and curvy. Exaggerating features is a great way to create a cartoony look. His hands and feet are slightly oversized and rounded, and his expression should be big and bright.

4

Outline his hat, bandanna, and the buttons on his shorts. Using a ruler, lightly pencil in a long, straight line, resting on his right shoulder. Small triangles create a glimmer in his pupils.

TOP ART TIP!

The key to drawing cartoon characters is to keep things as simple as possible. Minimalist detail will make your character look more expressive!

5

Using your guides, sketch Stringles. If you're struggling with the body's shape, try drawing two overlapping circles. This will help form the main outline.

6

Detail Toona Fish's belt and buttons. Add shape to Stringles and give him a big, happy smile. Remember to keep your lines simple!

7

Use fine lines to draw the guitar strings. A ruler will help keep them straight. Lightly mark where shadows fall on Toona Fish's figure, and darkly shade his pupils and open mouth.

8

Add heavy blacks to the darkest areas of your drawing. Leave bright glimmers in Toona Fish and the guitar's eyes! Add soft shadows to his body. Toona Fish is 2D, so he only needs a touch of shading— too much could make him pop into 3D!

TOP ART TIP!

This aspiring rainbowfish is on a mission to make things colorful. Why not experiment with coloring pencils to brighten up this Outfit?

HOW TO DRAW:
MIDAS

1

Start with a light sketch of your character's framework, paying attention to his angled pose.

TOP ART TIP!

Consider sketching cross-contour lines on Midas's arms before placing his tattoos. This will clearly show the curve of his arms so you can draw his tattoos accurately.

2

Begin fleshing out your drawing. Midas's stance means the ovals forming his thighs and knees overlap slightly.

3

Continue adding shape to your character, using curved lines for his neck and torso. Outline his hands, fingers, and feet.

4

With a firmer shape in place, begin outlining his weapons. Pencil in his waistcoat, pants, and shoes.

5

Sketch his facial features and continue detailing his weaponry. Add a tie, buttons, pocket, and chain to his Outfit. Mark buckles on his shoes.

TOP ART TIP!

Midas's hair falls away from the neat parting in sections. Remember to give his hair plenty of volume, raised above the outline of his head to make his undercut stand out.

6

Draw Midas's facial features. Though his head is tilted, he is staring straight at us. Begin outlining his tattoos.

7

Define his facial features and add sections to his hair. Take your time adding his tattoos. Mark areas of shadow on his hands to capture their golden glimmer.

8

Finish by adding low-contrast shading to your drawing, keeping your strokes light and even. Leaving areas of bright white highlights on his hands will capture Midas's golden touch.

TOP ART TIP!

Clever shading can prevent tattoos from looking flat! Use highlights where light hits the skin (or where Midas's tattoos turn gold!) and carefully blend darker areas of shadow.

HOW TO DRAW:
CLUCK

1 Begin with a light sketch of Cluck's framework. Use a circle for his head. Keep his stance wide and open.

2 Sketch large, wide ovals to capture this eggsplosives expert's bulky form. Keep his forearms and lower legs slim, using smaller ovals.

3 Begin firming up Cluck's shape, joining the ovals together. Sketch his thin legs and outline his hands and feet. A large rectangle forms the shape of his gun.

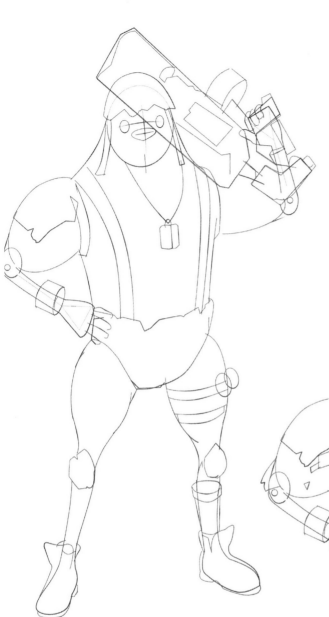

4

Use your guidelines to mark Cluck's eyes, beak, and boots. Add his cracked shell helmet and shorts. Begin defining the shape of his gun and outline the eggs strapped to his left thigh.

5

Begin to erase rough linework and firm up Cluck's shape. Pencil in his shoulder pads and leg straps. Begin outlining his feathers.

TOP ART TIP!

Less is more when it comes to texture. Adding a few detailed sections of triangles to show his feathers is more effective than covering his whole body!

DRAW:

6 Begin adding detail to Cluck's gun. Simple shapes like circles can create bolts and buttons, giving the gun a mechanical look.

7 Add depth to Cluck's feathered sections by adding close parallel lines around the shapes. Add detail to his armor, and draw his braces and bootlaces. Darkly shade his eyes, leaving bright white spots for a friendly expression.

TOP ART TIP!

To show the flexibility in Cluck's dog tag chain, stack cylinders where the links are most relaxed and draw well-spaced V-shapes where the chain stretches.

8

Finally, add value to your drawing. To give him a feathery look, keep your pencil strokes soft, contrasting with firmer shading on his gun. Now Cluck will be ready to prove he's no chicken!

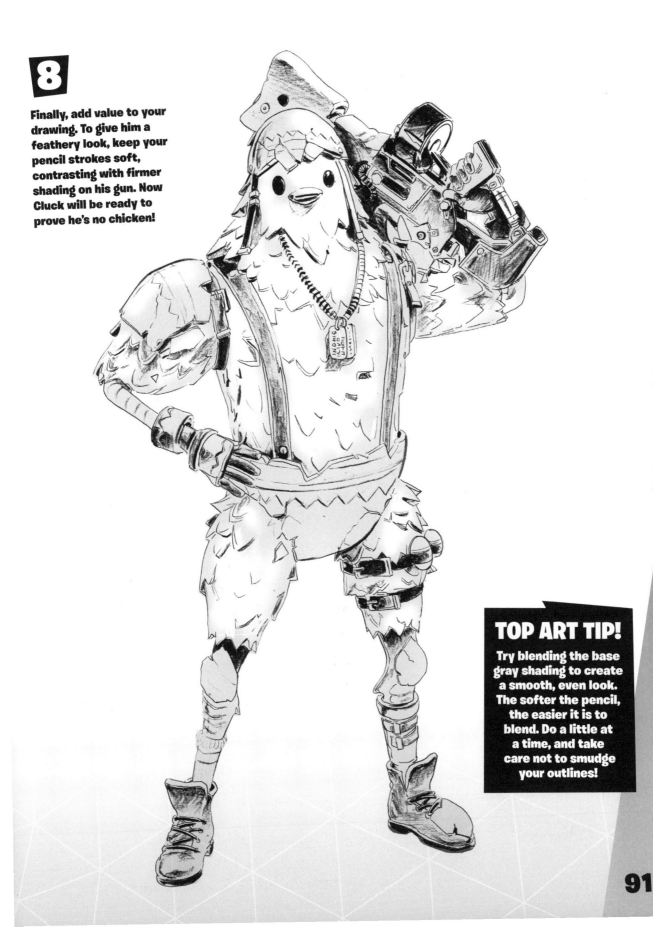

TOP ART TIP!

Try blending the base gray shading to create a smooth, even look. The softer the pencil, the easier it is to blend. Do a little at a time, and take care not to smudge your outlines!

HOW TO DRAW:
TURK

1

Reel in your enemies with this Outfit. Begin with a sketch of Turk's frame. Take care capturing the tilted angle of his head.

2

Overlap a series of ovals to create his base shape. Turk is wearing thick layers, which make his figure look bulky.

3

Continue adding shape to your figure. Mark the position of his fingers and pencil in the shape of his feet. His toes are pointing towards us, making the front of his feet look flat.

4 Use rough lines to outline the shape of his pants. The fabric is firm, so the folds in the material will be harsher than the gentle curves of soft fabric.

5

Use simple shapes to add detail to Turk's outfit, such as patches, a knee pad and belt buckle. Curve his life preserver around his neck. Begin outlining his fishing rod with a long, curved line and a small circle. Pencil in his hat, hairline and facial hair.

TOP ART TIP!

Drawing a hand gripping something is similar to drawing a clenched fist. Sketch a closed fist, then draw the item on top. Erase any lines which would be covered by the hand's grip.

6 Begin to firm up your linework. Pencil in the rod guides using small circles and add a hook. Mark short, curved lines on Turk's hat and add detail to his face, taking care to capture his expression.

7

Add finer detail to your drawing, marking creases in his clothing, as well as areas of shadow and highlights. Add soft feathers to the rod's hook, contrasting the firm lines of the handle.

TOP ART TIP!

Planning where you will add shading means you can add value with confidence. Block in shadows first, then define the highlights.

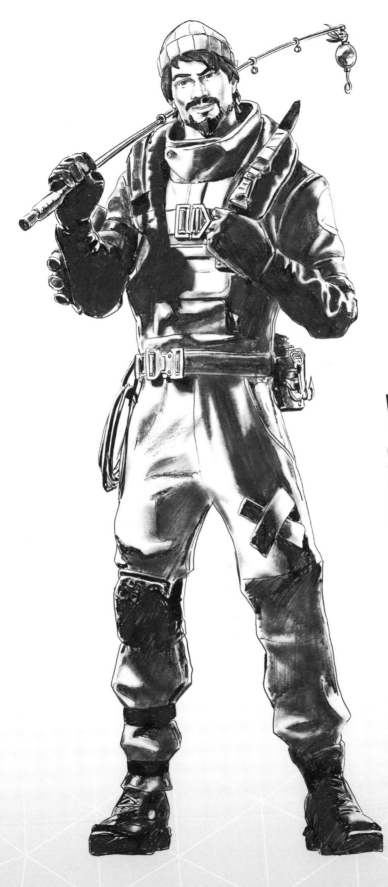

8

Using your guides
from the previous
step, add value
to your drawing.
Gradually build
the blacks in the
darkest areas.

TOP ART TIP!

Capture the
rubbery, waterproof
appearance of Turk's
fishing overalls by
leaving large areas
white where light hits
the outfit.

HOW TO DRAW:
ETERNAL KNIGHT

1 Start drawing this Outfit by sketching your figure's framework. Eternal Knight's pose will challenge perspective, so take your time getting the proportions right.

2 Begin adding shape to your frame, keeping the ovals long and slim to reflect her slender figure.

3 Use your rough sketch to begin firming up your character. Mark the position of her curled fingers and outline her feet.

4

Begin shaping her armor. It fits snugly, closely following the shape of her body. Pencil in the outline of her swords, breaking them down into rectangles and parallelograms.

TOP ART TIP!

A cuboid forms the base shape of her pouch. Round the edges to give it a softer look, use short lines to form the flap, and add a small round button.

TOP ART TIP!

Use the eye guideline as a starting point and gradually build the helmet's outline. Her helmet is symmetrical, so use a ruler for neat lines—and don't rush!

5

Continue adding detail to her armor, including the triangular spikes on her shoulder pads. Decorate her blades, kneecap, and skirt.

HOW TO DRAW:
ETERNAL KNIGHT

6

Erase your rough linework and continue adding detail to your Outfit. Mark the red splatter on Eternal Knight's chest plate and the curved grooves in her swords.

7

Take your time adding finishing touches to her armor and weapons. Use cone shapes to add sharp fingertips to her gloves.

8

High-contrast shading will really make Eternal Knight's armor shine! Use thick blacks for her base layer and keep her armor bright white, adding just a few areas of light shadow.

HOW TO DRAW:
MAVE

1

Start by sketching your figure, taking care to capture the fearless stance of this Outfit.

2

Build upon your initial sketch, adding shape to the body. Keep her pose tall and confident.

3

Begin to firmly outline your character's arms, legs, and torso, paying attention to the curve of her waist. Pencil in the shape of her fists and feet.

Sketch tight C-curves to mark her hairline, using softer lines for her ponytail. Outline the base shape of her outfit, staying close to her frame. Sketch a neat oval for her shield. Draw curved lines to form her blade, then add jagged lines to form the serrated edge.

Outline her shield with tight, rough waves. Add feathering detail to her shoulder pad and draw a loose line to form her loin cloth. Criss-cross lines up her boots to form laces.

TOP ART TIP!

Beware of feathers falling flat! Uneven layers will create depth. Give each feather a unique shape as they wrap around her shoulder.

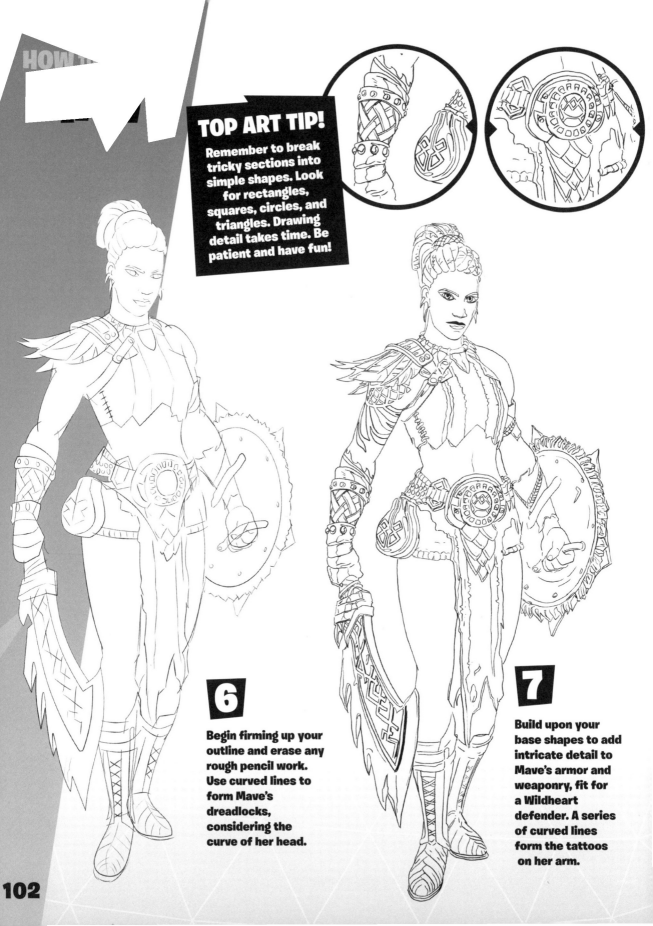

TOP ART TIP!

Remember to break tricky sections into simple shapes. Look for rectangles, squares, circles, and triangles. Drawing detail takes time. Be patient and have fun!

6

Begin firming up your outline and erase any rough pencil work. Use curved lines to form Mave's dreadlocks, considering the curve of her head.

7

Build upon your base shapes to add intricate detail to Mave's armor and weaponry, fit for a Wildheart defender. A series of curved lines form the tattoos on her arm.

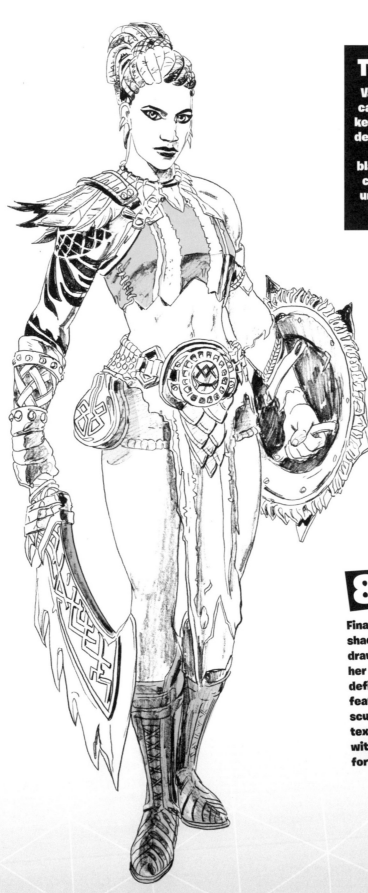

8

Finally, add a touch of shading to your drawing. Darkly shade her tattoos and add definition to the feathers. Light scumbling will add texture to her hair, with wide hatching forming her hair tie.

HOW TO DRAW:
MANCAKE

1

Let's see what this breakfast bandit is really made of. Begin by sketching his base frame, keeping his head square.

TOP ART TIP!

Notice how shapes shorten as they tilt away from you. But be careful: the width of the body part doesn't change. Look out for overly skinny limbs!

2

Flesh out your figure, using ovals to add shape. Mancake's chest is wider than his pelvis at this angle.

3

Firm up your figure, drawing his waist in slightly to emphasize the width of his chest and his tilted hip. Though his legs are straight, there's still a light dip behind his knees.

Sketch Mancake's clothes. A large X crosses his chest. Use curved lines to capture the sweeping movement of his poncho and scarf. Add a bulging bag hanging from his grip, ready to hold his loot.

5 Let's start adding delicious detail. Rectangles and cuboids form the sticks of butter strapped across his chest. Use tight waves to create a stacked effect around his head.

Large curved eyes and sharp eyebrows create Mancake's fierce expression. Outline his face with a runny helping of syrup, using long lines and curved edges to create a trickling effect.

TOP ART TIP!

The butter strapped to his chest curves around his body. Practice drawing cuboids from various angles—but don't worry about keeping their edges too neat!

105

7

Add fringes to the base of his scarf, curving the lines to create a sense of movement. Firmly outline his leg armor. Light squares create the straps around his calves.

8

Add the plaid pattern to his scarf and draw the seams on his armor, following the curve of his limbs. Sketch a stack of syrupy pancakes in his loot bag, decorating the sack with a dollar sign.

TOP ART TIP!

To draw plaid, roughly sketch well-spaced horizontal lines, then add vertical ones. Draw parallel lines beside every second line, horizontal and vertical. Keep your pencil work loose and ensure all the lines curve with the material.

9

Before setting out to wreak pancake havoc, shade your drawing. Apply some light hatching to the base of Mancake's poncho and firmly mark the plaid lines on his scarf. Give him heavy, dark eyebrows to capture his fierce expression.

TOP ART TIP!

Add smooth splodges of highlights to create a buttery look on the sticks. Contrast flat grays with bright whites to create a syrupy shine on Mancake's head, using thicker grays on the looted pancake stack.

HOW TO DRAW:
THE
FOUNDATION

1

Drawing the Leader of The Seven is no mean feat! Begin by pencilling his base frame, keeping his stance wide.

2

Begin adding shape to your character. The Foundation's neckline isn't visible, with his chin overlapping his chest.

3

Continue fleshing out your drawing. Sketch his hand placement, considering the size and shape of his weapon.

Begin shaping his helmet and the armor around his shoulders. A large parallelogram forms the base shape of his gun. Sketch a simple outline for his cape.

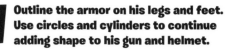

Outline the armor on his legs and feet. Use circles and cylinders to continue adding shape to his gun and helmet.

Use simple lines to gradually build shape on his upper-body armor. There's lots of detail here, so take your time.

TOP ART TIP!

Capes add a lot of drama to a character's outfit, but they don't need to be overly detailed. Simple long, sweeping lines create a dynamic look.

7

Use simple shapes to define the armor on his legs. Though his feet look square, draw the shoes around a basic foot shape to help keep everything proportional.

8

Firm up your pencil work and add finer detail to your drawing. Vary your line weight when detailing his armor to create depth.

TOP ART TIP!

While everything can be broken into basic shapes, very detailed drawings can become confusing. Gradually layer on detail in the main areas of focus to draw the eye to key parts of the design, working on small sections at a time.

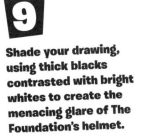

9

Shade your drawing, using thick blacks contrasted with bright whites to create the menacing glare of The Foundation's helmet.

TOP ART TIP!

To give The Foundation a metallic look, carefully consider where light reflects off of his armor. Keep your lines smooth. Contrast this with thick, heavy shading in the darkest areas to give the highlights some extra punch!

Cataloguing in Publication Data is available from the British Library

Paperback 978 14722 9152 3

Written by Kirsten Murray

Illustrations by Mike Collins

Design by Amazing15

All images © Epic Games, Inc.

Printed and bound in Bosnia and Herzegovina

Headline's policy is to use papers that are natural, renewable and recyclable products and made from wood grown in sustainable forests. The logging and manufacturing processes are expected to conform to the environmental regulations of the country of origin.

HEADLINE PUBLISHING GROUP
An Hachette UK Company
Carmelite House
50 Victoria Embankment
London, EC4 0DZ
www.headline.co.uk www.hachette.co.uk

www.epicgames.com